DETECTIVE COMICS

The Complete Covers

VOL. 2

INSIGHT 👁 EDITIONS

San Rafael, California

The Silver Age of Comic Books took place between 1956 and approximately 1970 and was the second major era of American comics. This period saw the deepening of the mythos of different characters and the DC Universe itself, as well as an increasing number of horror, crime, and romance titles. One of those crime comics was *Detective Comics*, which had first featured Batman in issue #27 (May 1939). Batman headlined almost every issue of *Detective Comics* from then on, and the

Silver Age saw the introduction of notable Batman supporting characters such as Barbara Gordon's Batgirl (May 1964). The Bronze Age of Comics ran though the early 1970s into the mid '80s, revitalizing Batman as a more brooding and dark hero, an interpretation of the character that has lasted to present day. This collection contains *Detective Comics* covers from issues #301 to #600, celebrating the Batman story arcs of the Silver and Bronze eras and the beginning of the Modern Age.

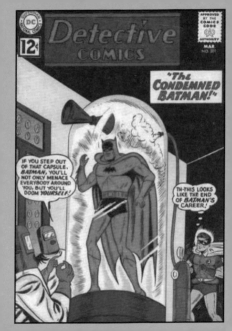

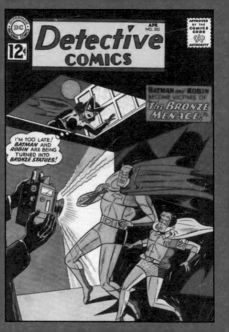

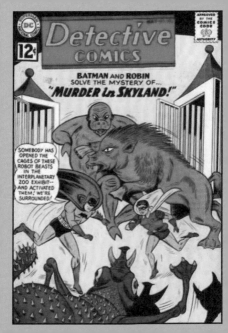

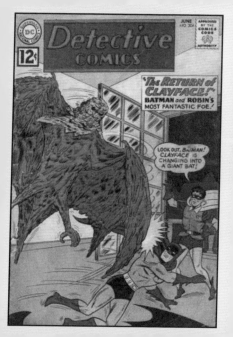

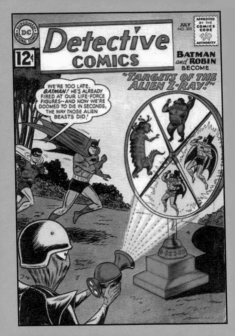

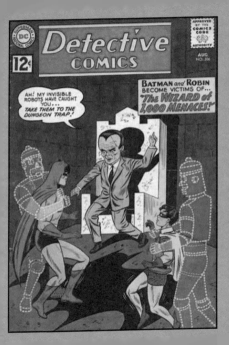

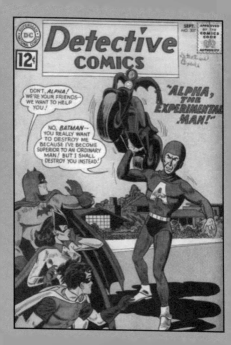

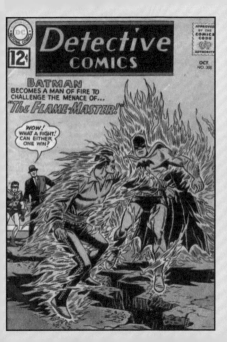

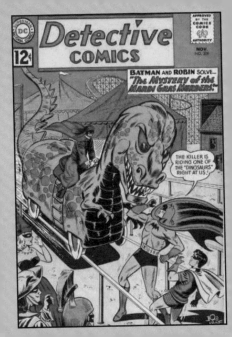

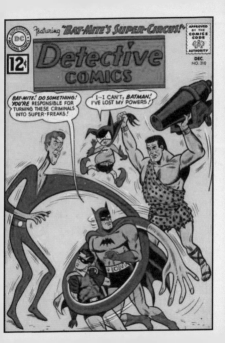

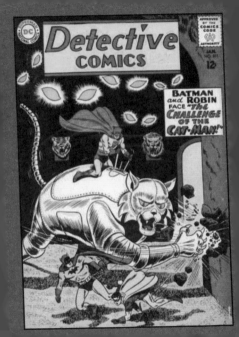

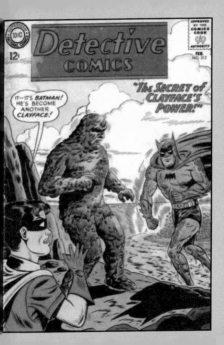

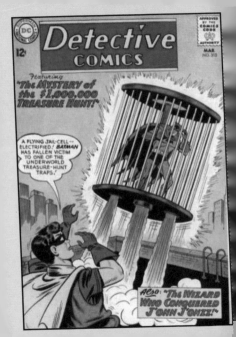

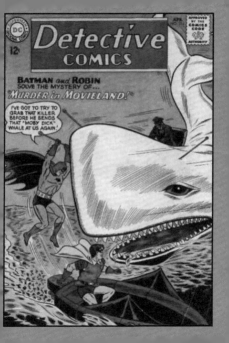

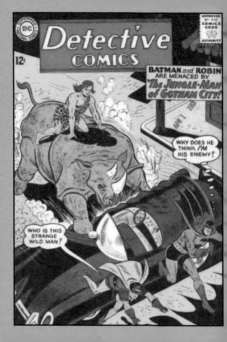

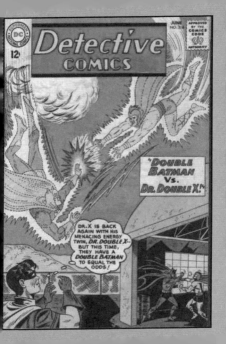

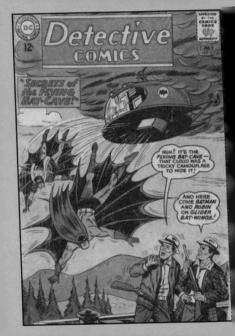

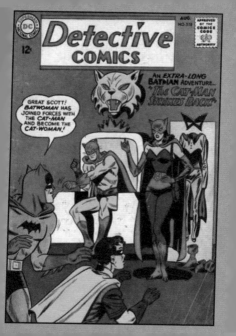

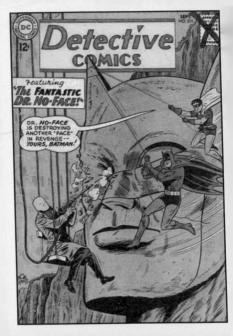

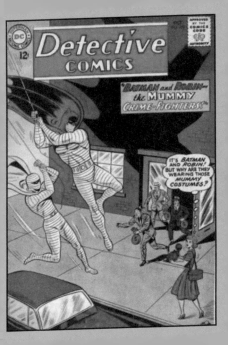

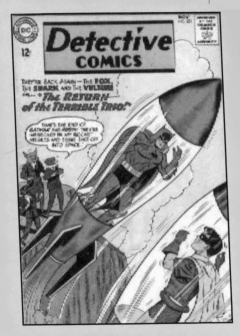

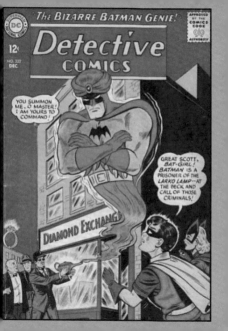

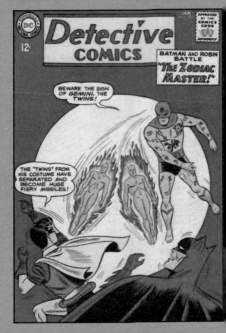

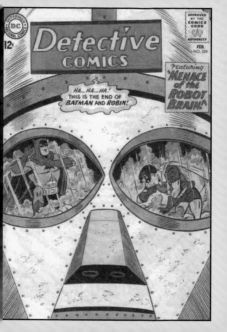

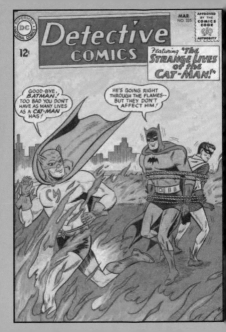

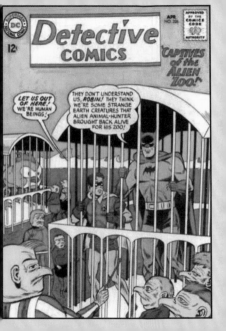

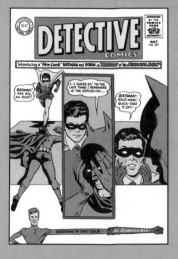

Detective Comics #327
This issue features a redesign for
Batman and Robin and introduced the
bat-symbol within the yellow oval.

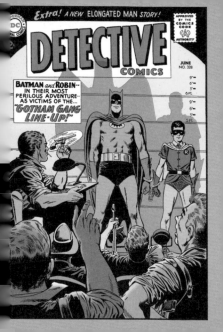

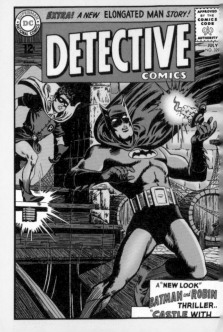

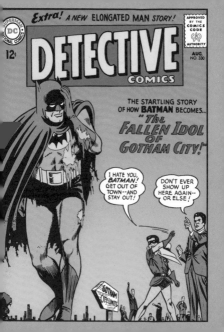

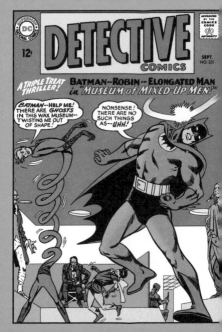

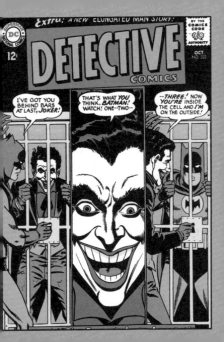

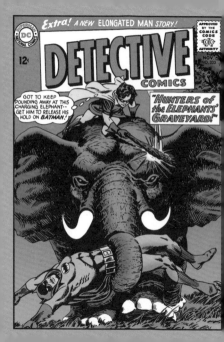

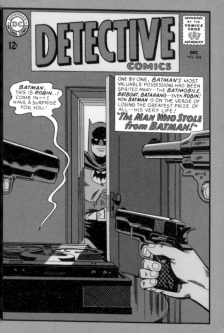

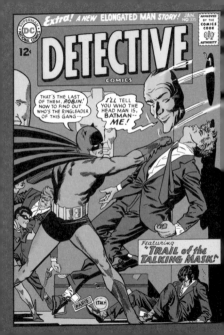

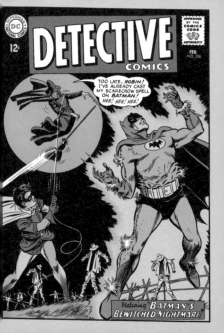

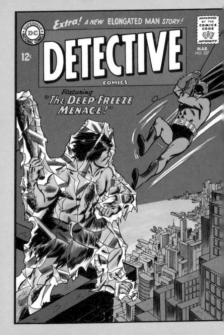

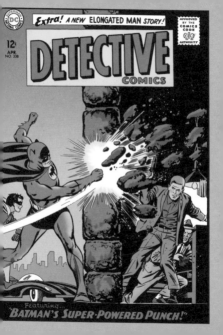

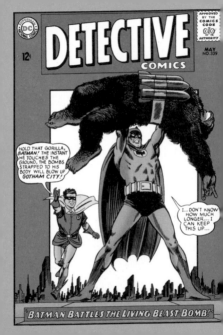

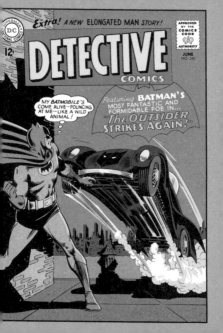

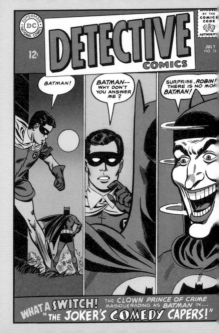

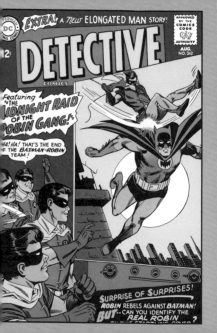

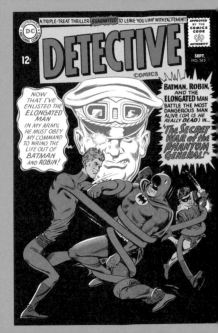

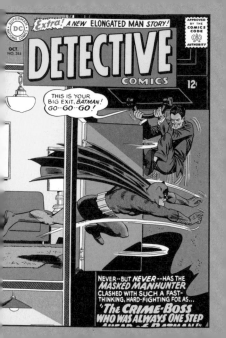

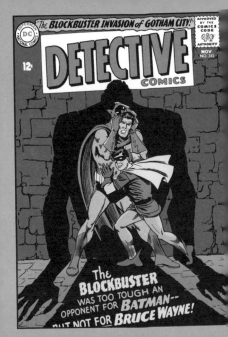

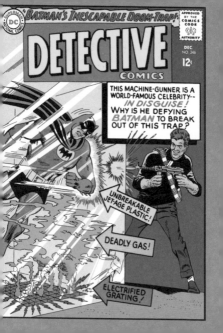

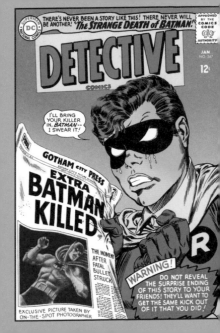

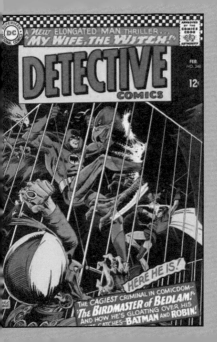

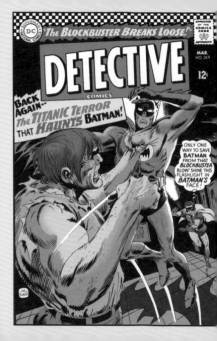

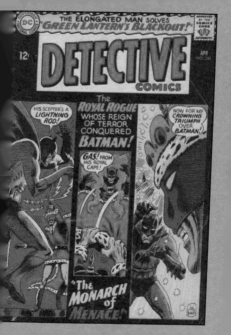

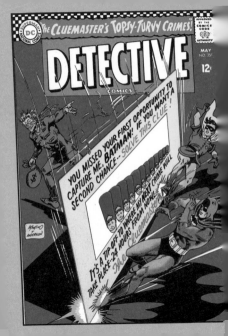

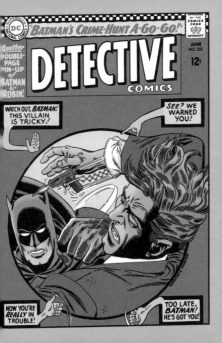

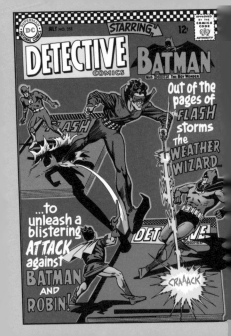

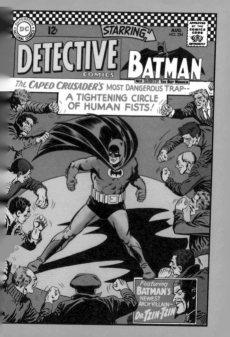

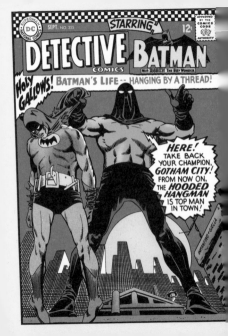

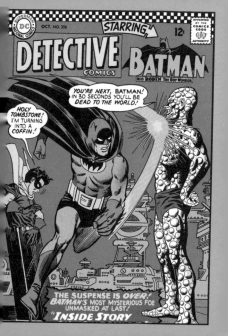

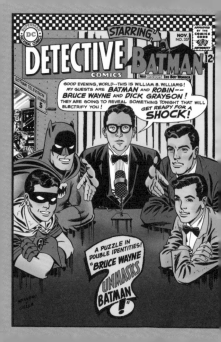

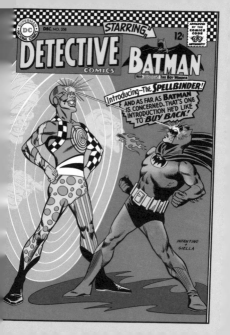

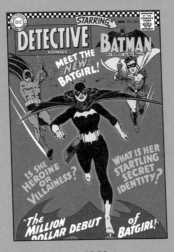

Detective Comics #359
This issue introduces Batgirl.
Batgirl's secret identity is Barbara
Gordon, daughter of Gotham City
police commissioner James Gordon.

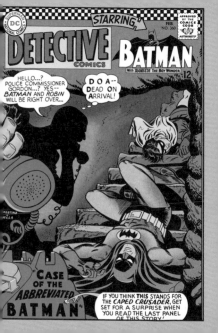

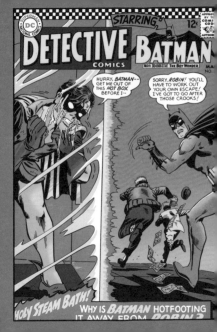

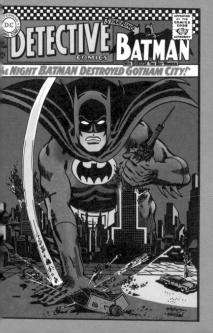

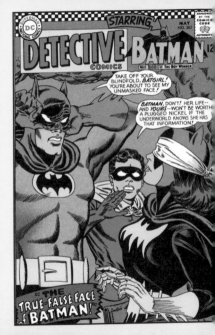

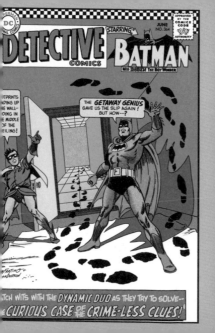

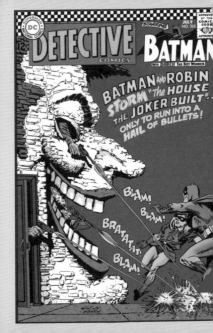

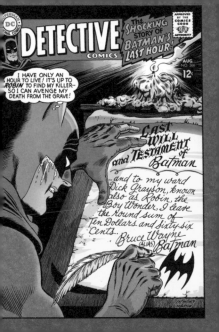

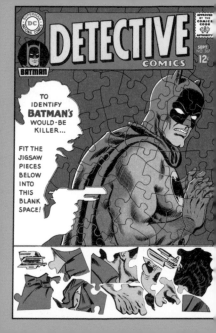

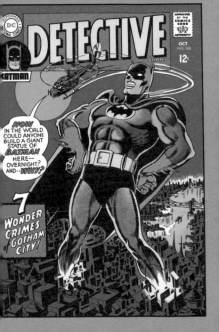

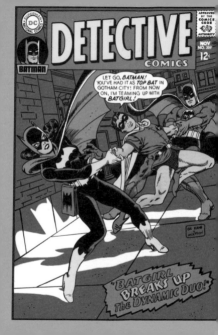

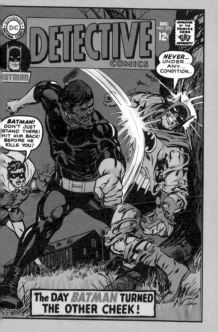

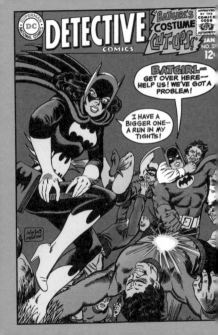

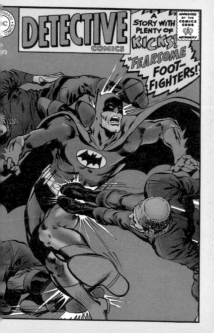

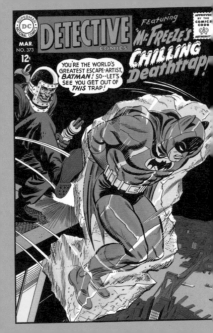

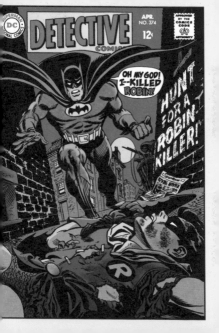

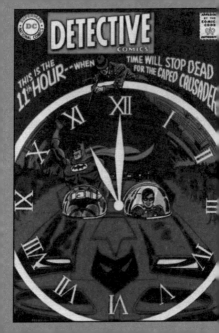

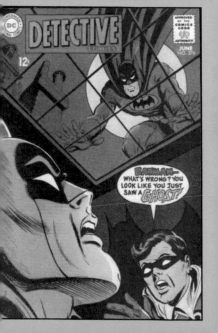

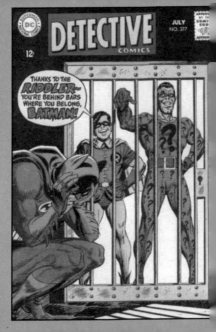

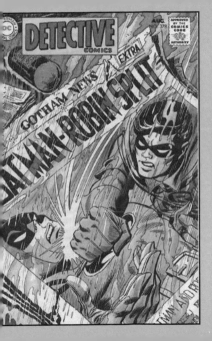

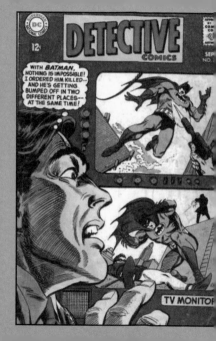

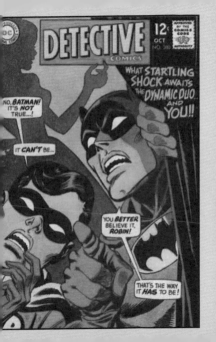

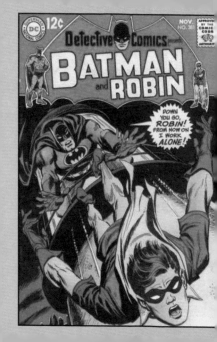

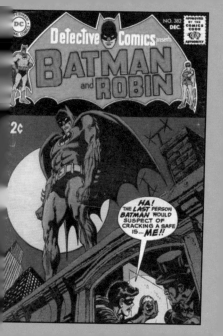

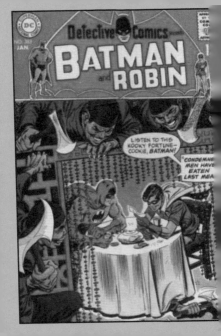

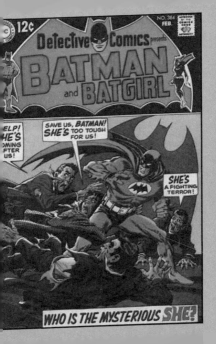

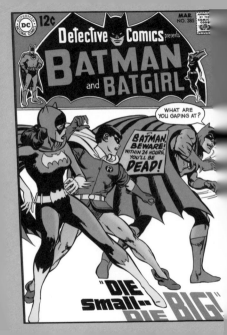

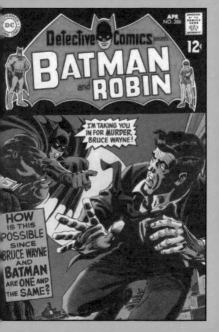

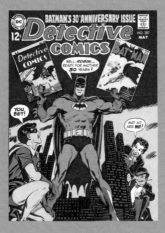

Detective Comics #387
This issue celebrates the thirty-year anniversary of Batman's first appearance. Irv Novick and Gaspar Saladino worked on the cover alongside Bob Kane.

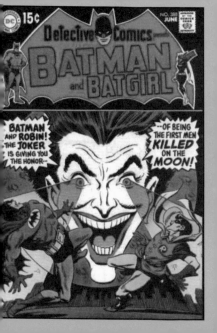

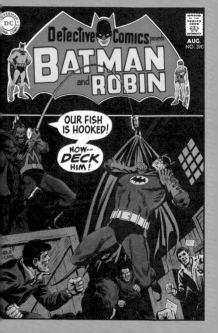

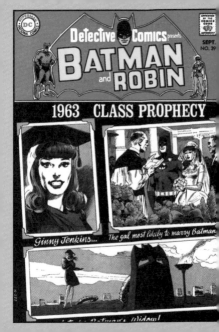

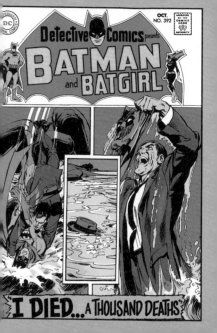

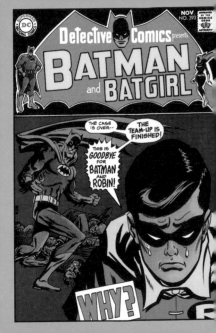

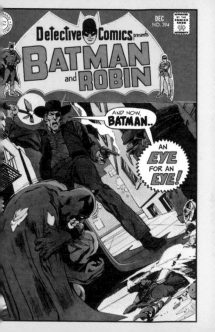

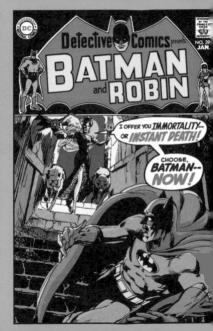

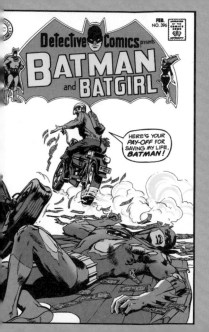

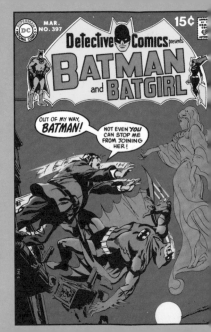

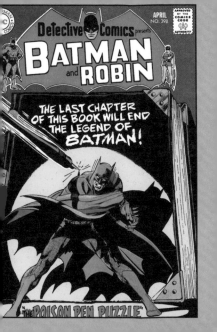

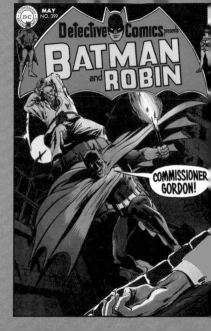

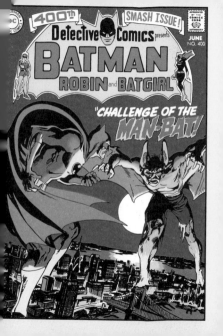

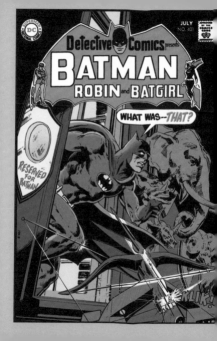

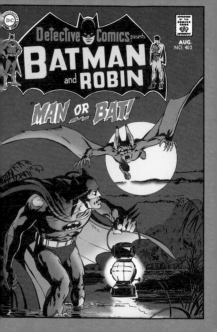

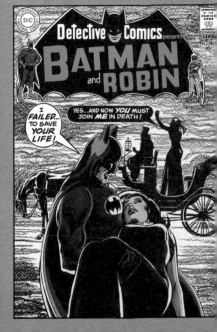

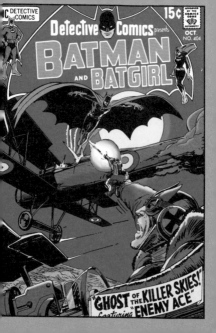

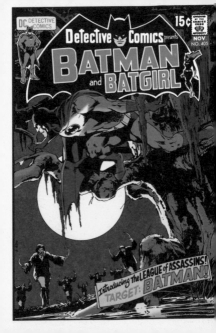

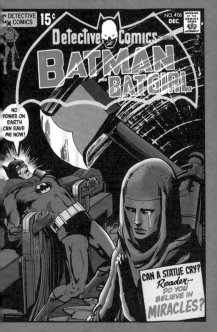

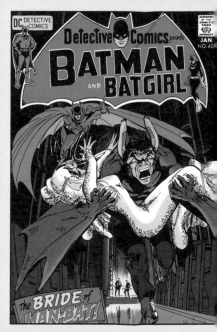

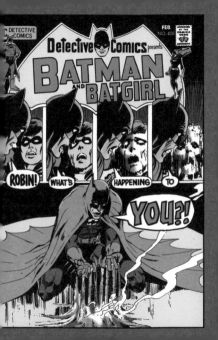

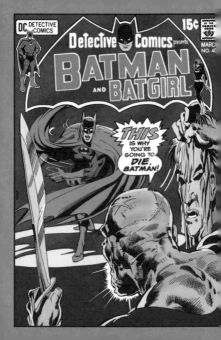

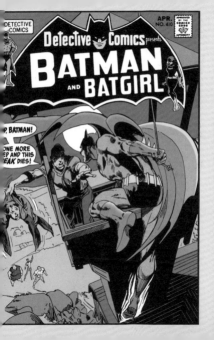

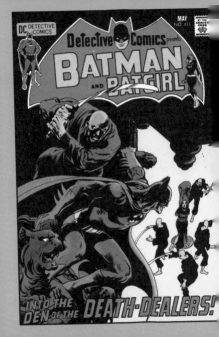

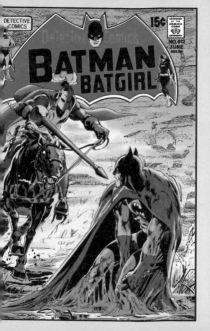

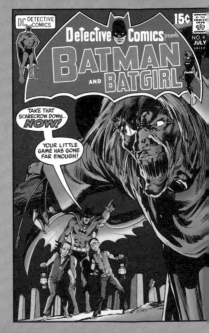

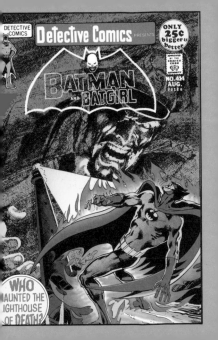

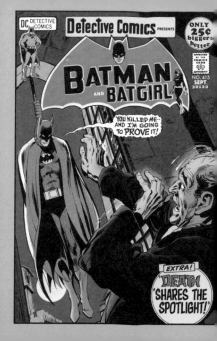

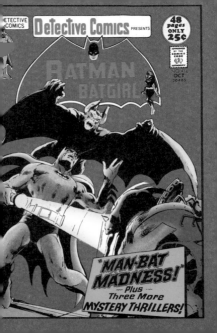

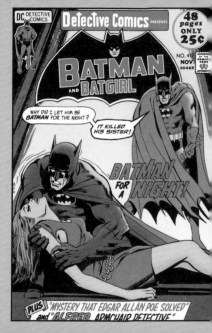

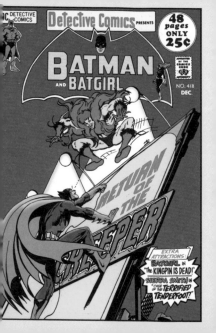

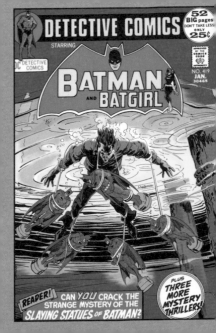

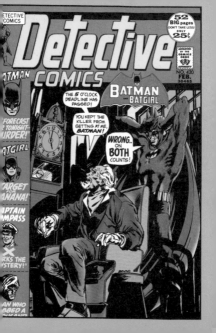

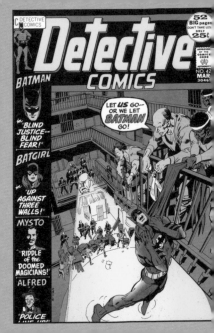

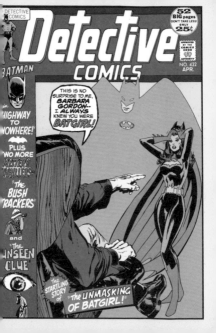

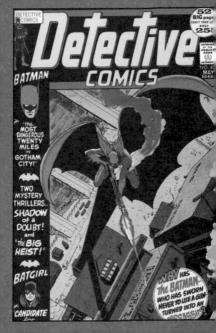

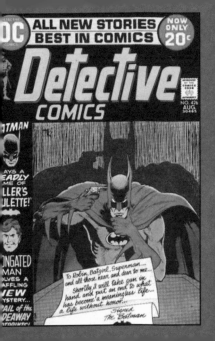

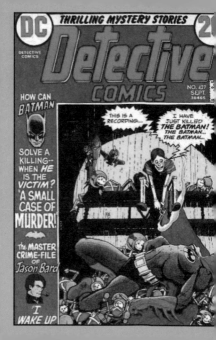

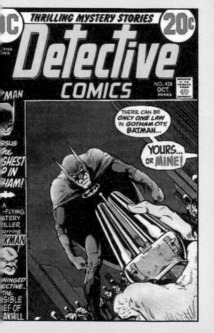

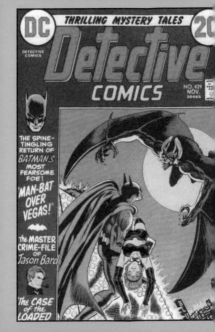

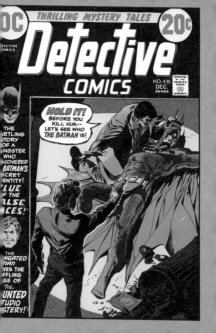

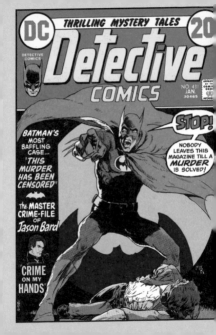

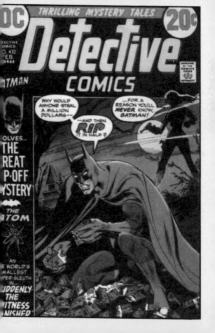

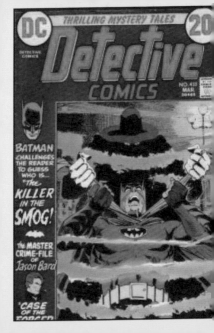

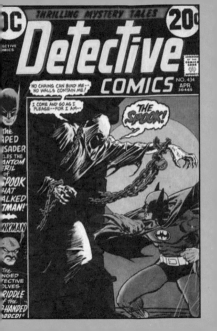

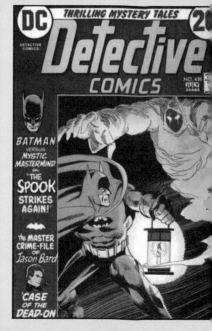

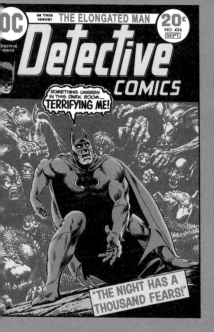

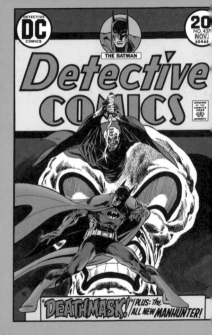

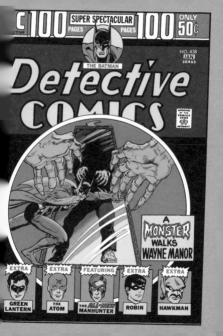

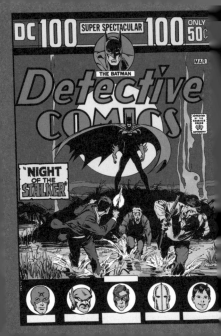

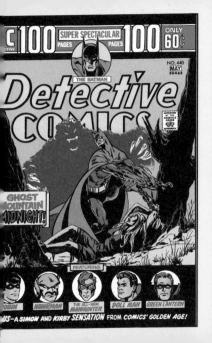

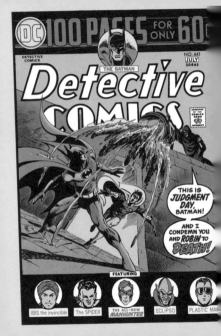

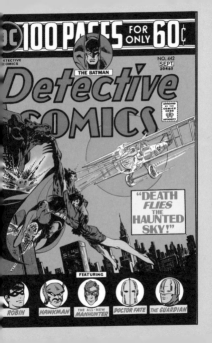

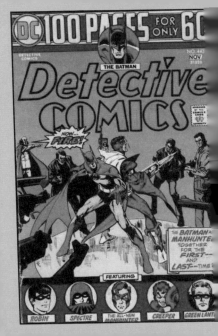

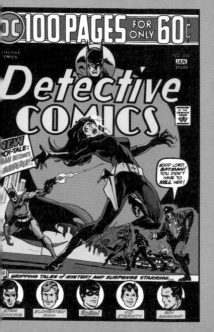

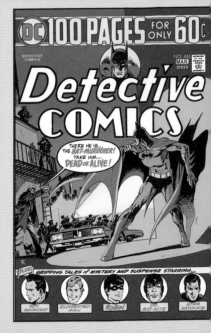

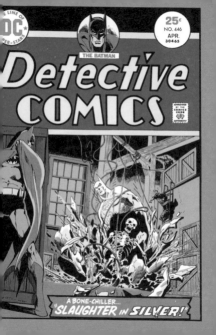

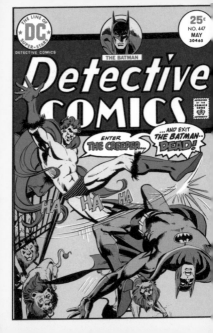

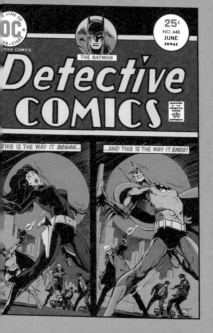

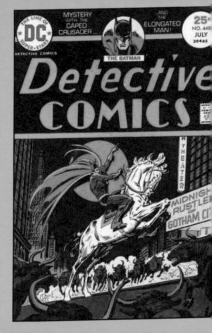

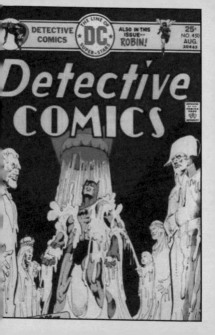

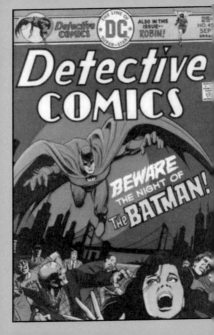

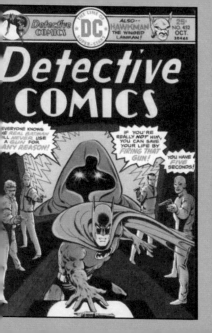

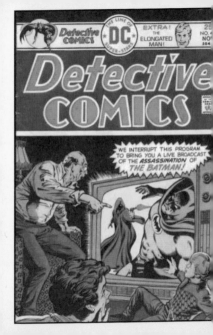

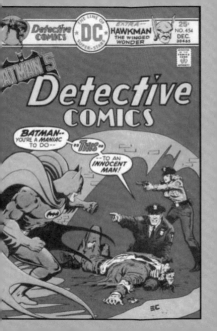

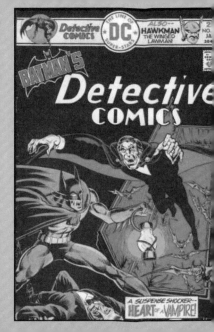

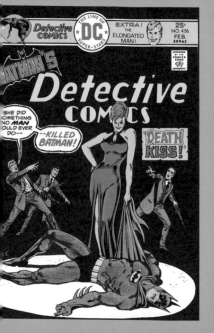

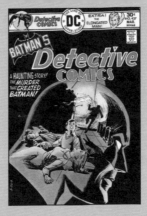

Detective Comics #457
A retelling of Batman's tragic backstory, issue
#457 added more detail to Thomas and
Martha Waynes' fateful night in Crime Alley.
This issue also introduces readers to Dr. Leslie
Thompkins, a close colleague of the Waynes
who eventually becomes an ally of Batman.

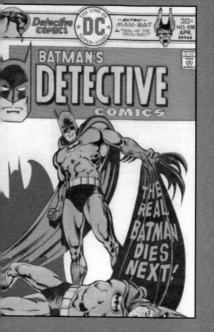

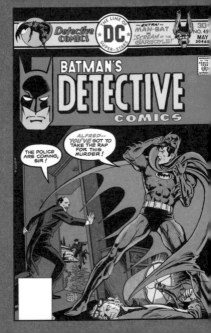

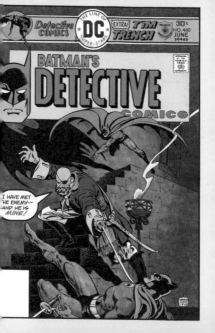

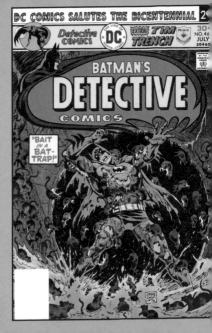

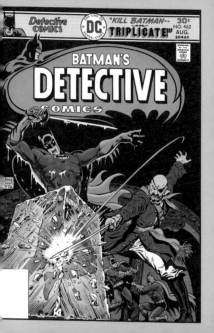

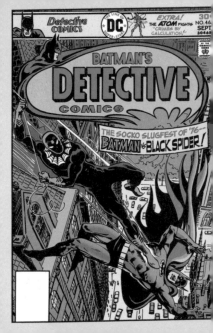

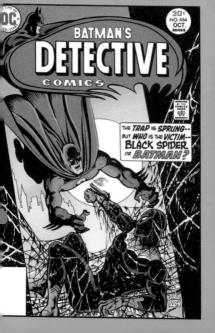

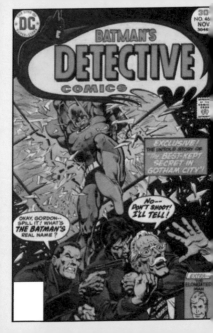

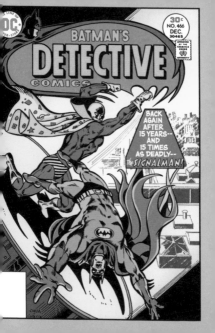

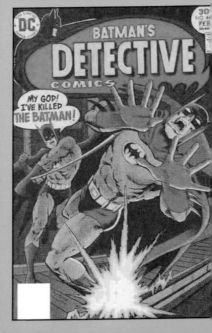

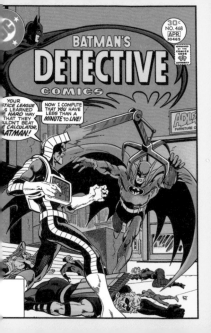

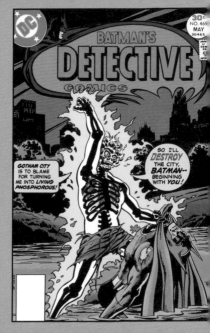

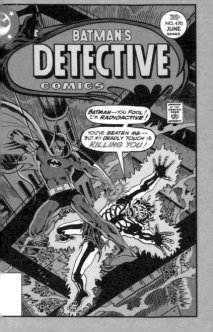

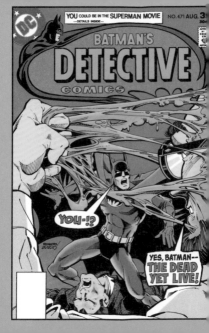

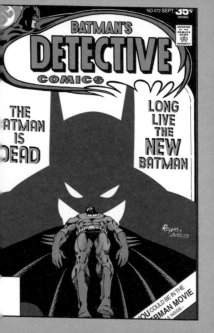

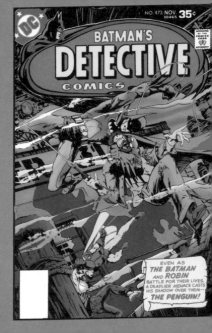

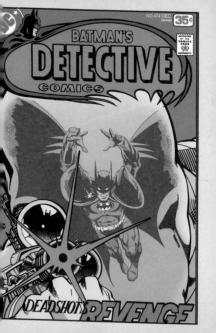

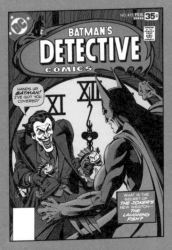

Detective Comics #475
In the popular "Laughing Fish" story arc, the Joker tries to trademark his sinister grin after it appears on the fish of Gotham City.

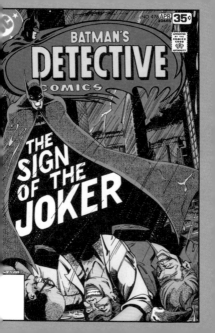

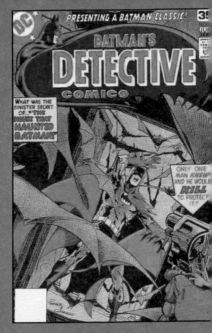

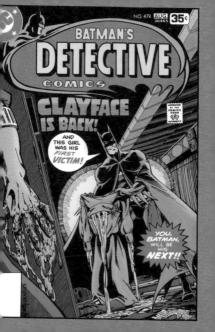

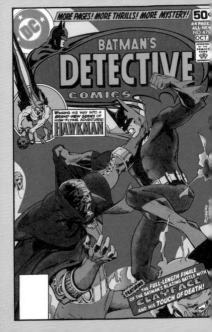

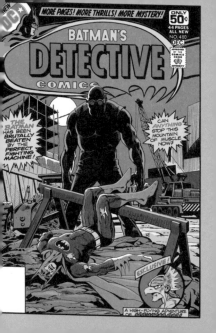

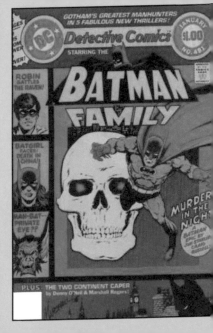

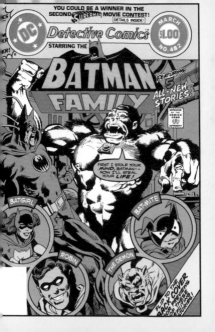

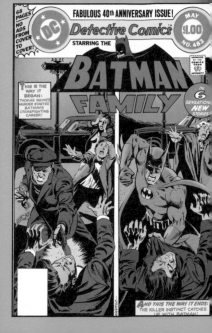

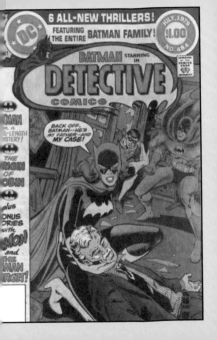

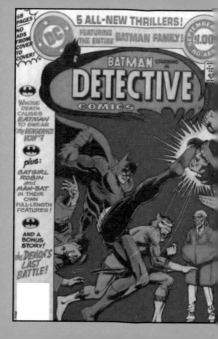

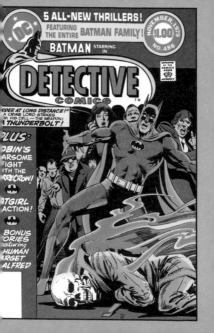

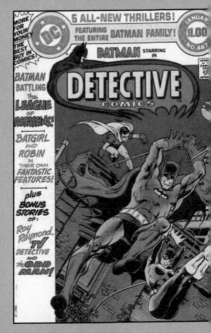

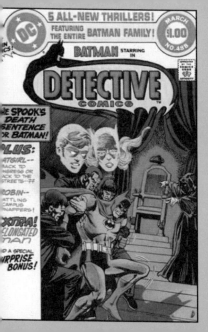

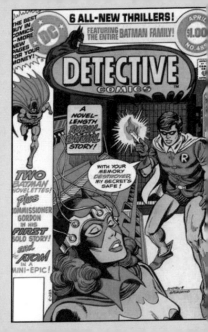

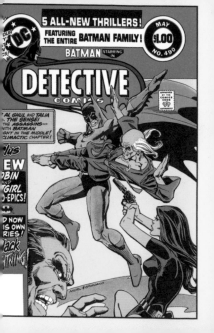

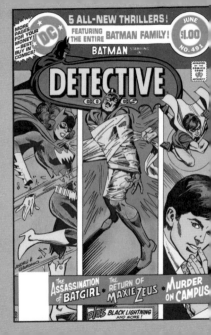

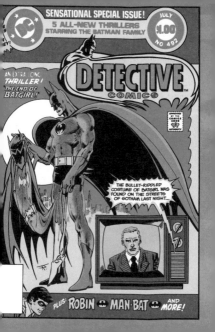

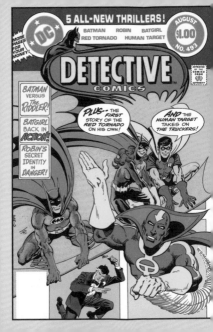

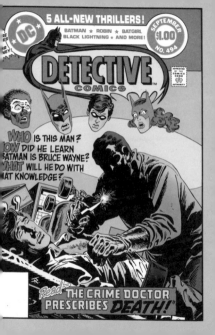

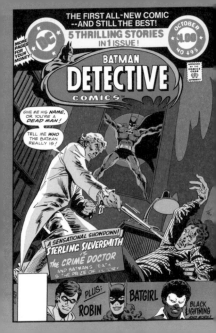

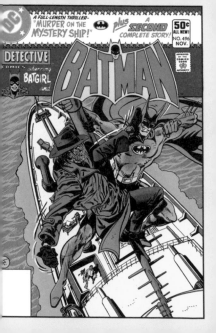

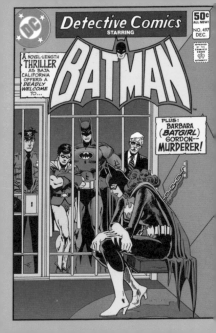

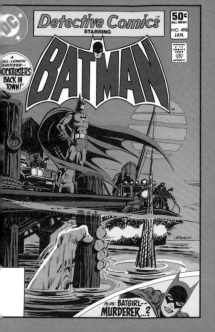

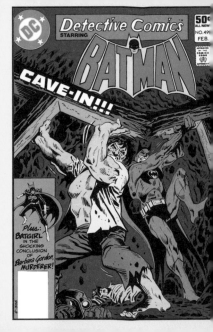

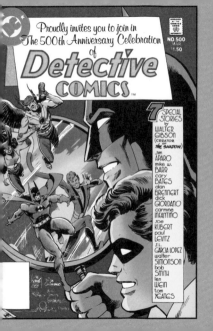

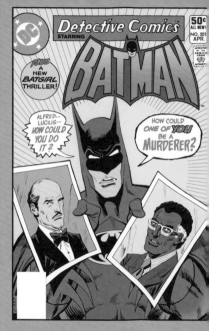

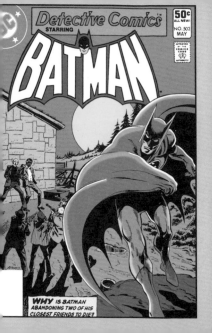

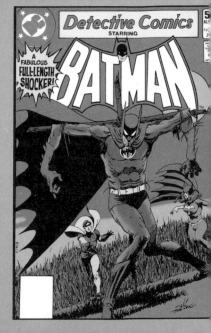

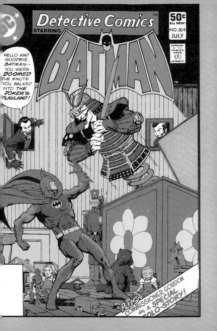

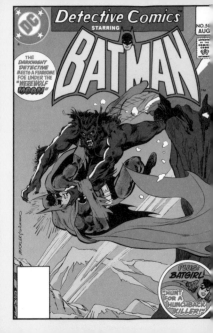

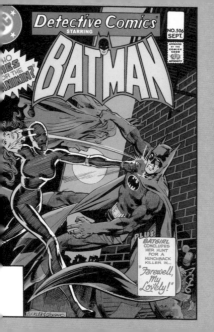

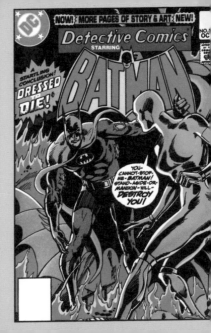

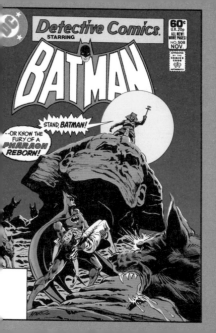

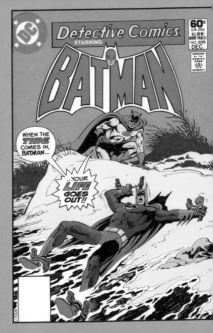

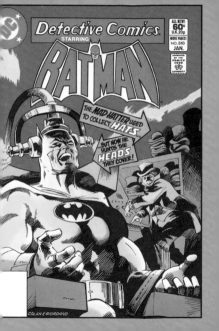

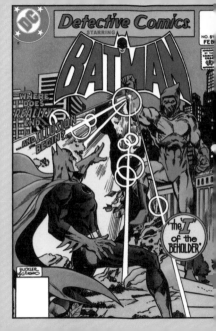

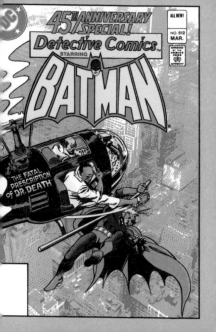

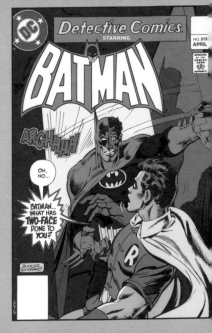

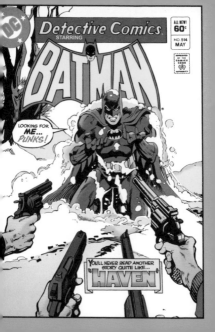

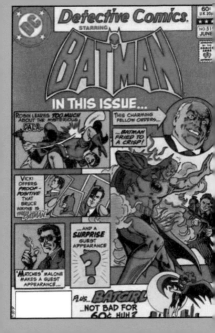

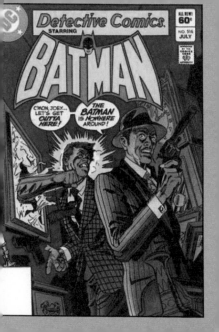

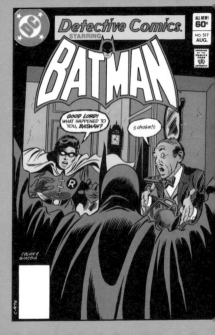

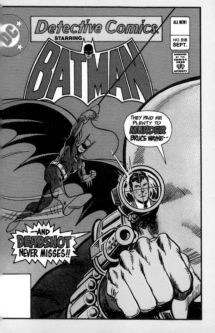

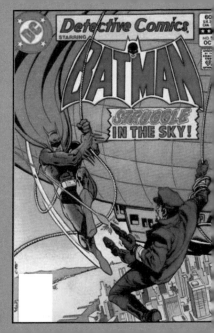

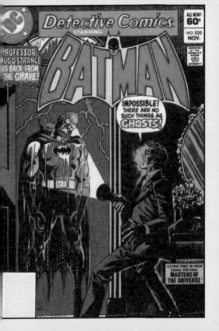

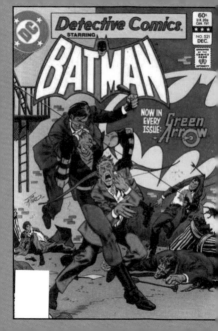

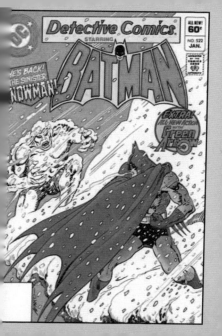

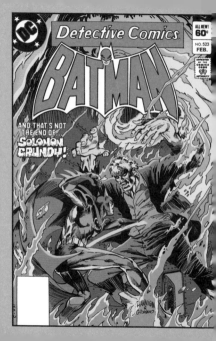

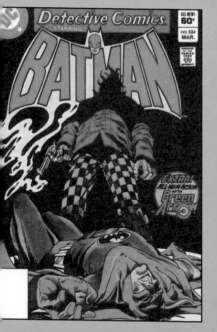

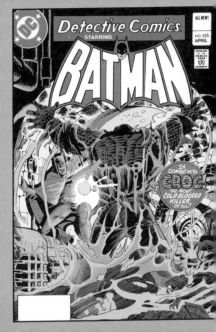

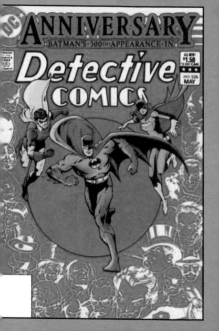

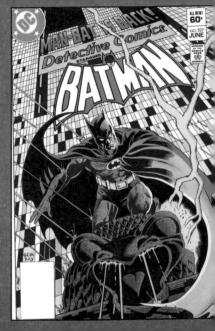

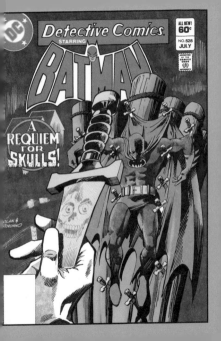

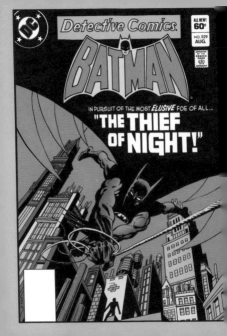

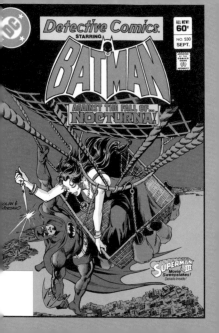

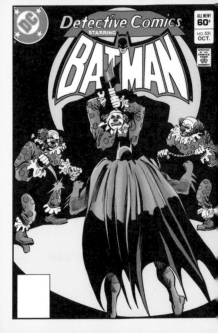

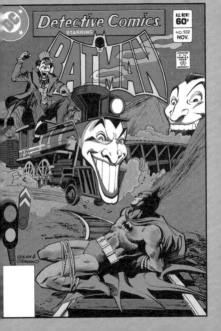

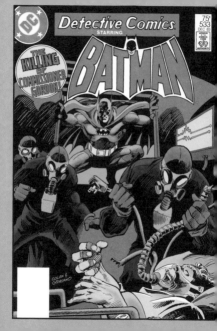

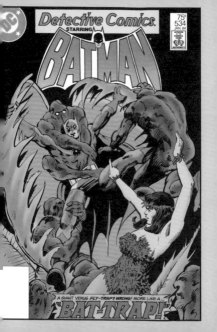

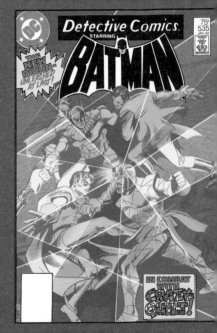

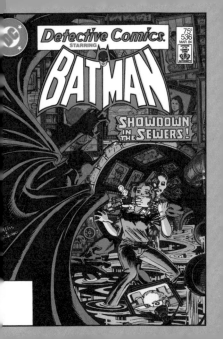

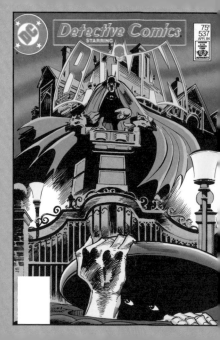

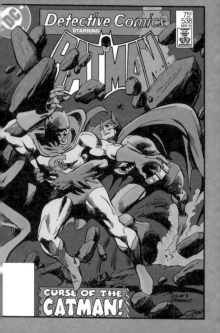

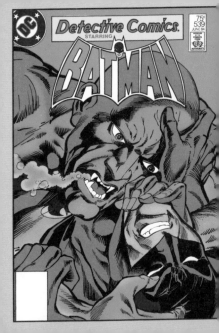

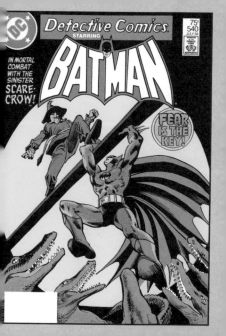

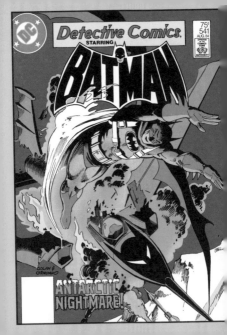

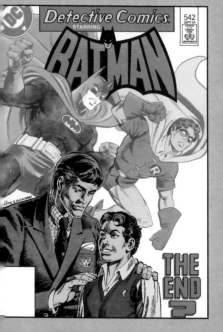

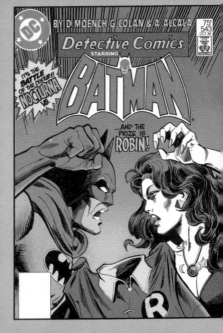

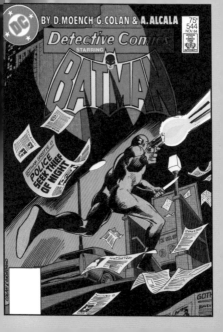

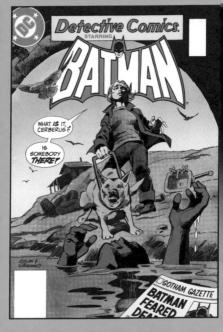

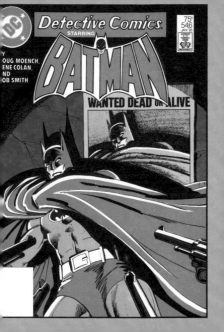

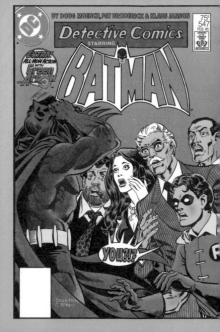

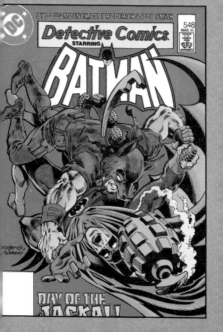

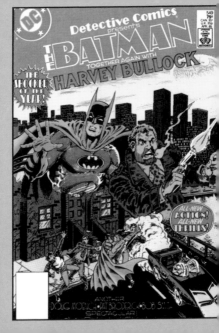

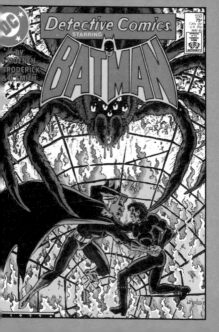

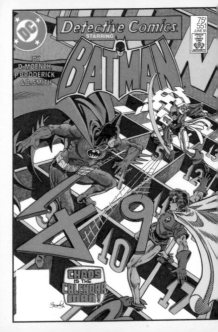

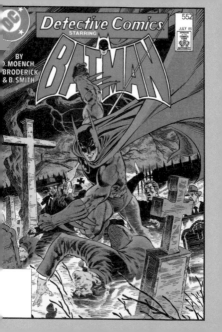

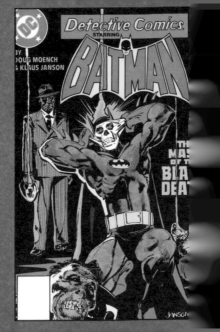

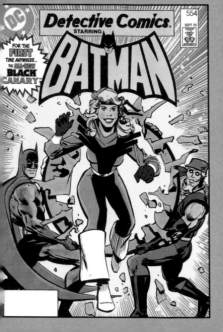

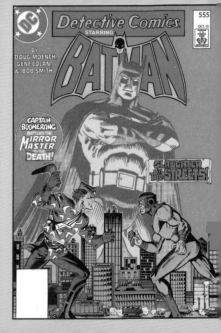

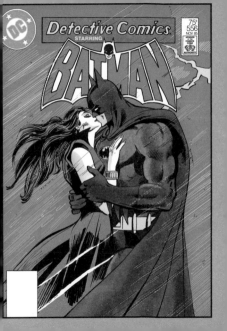

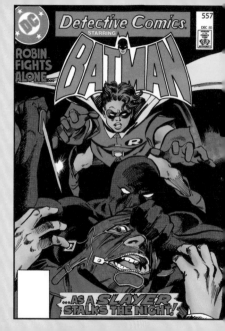

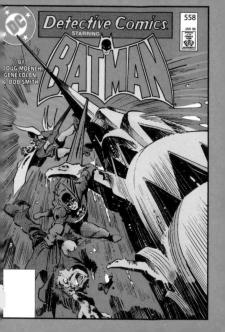

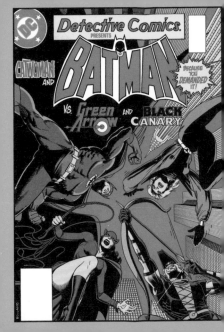

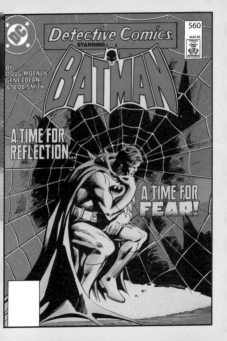

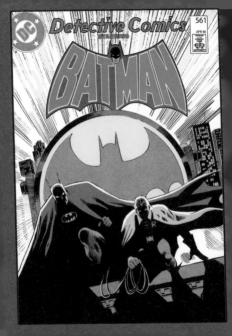

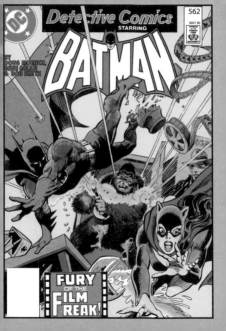

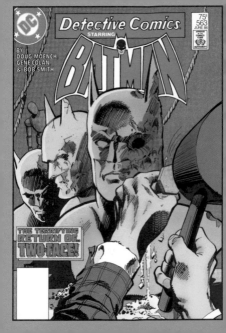

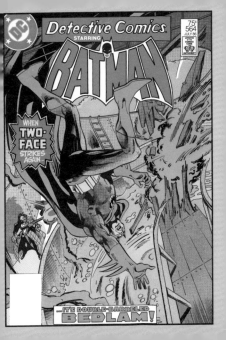

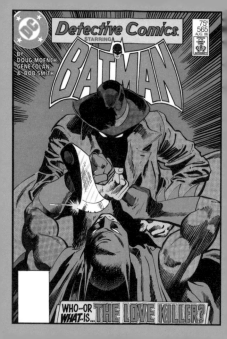

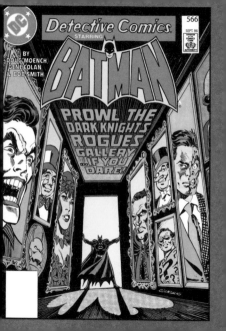

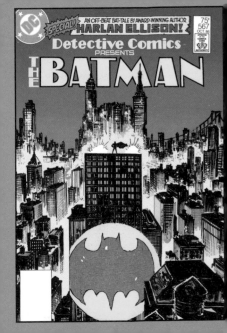

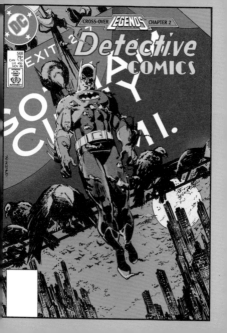

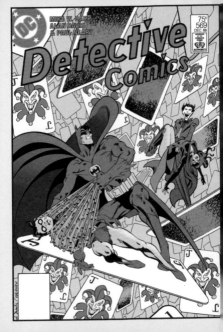

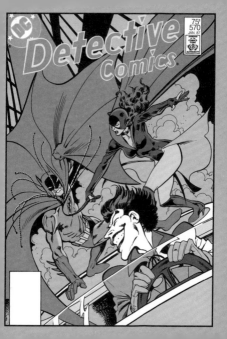

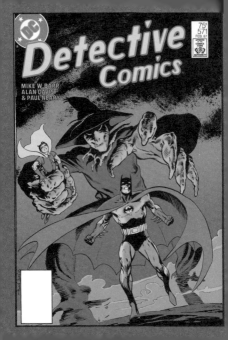

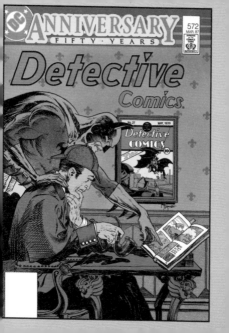

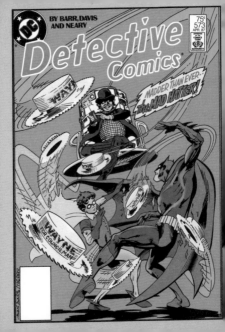

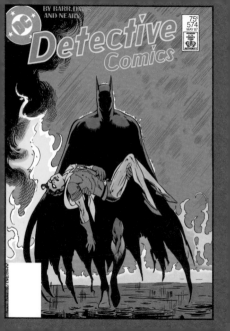

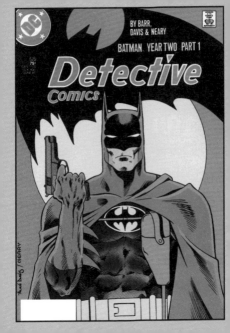

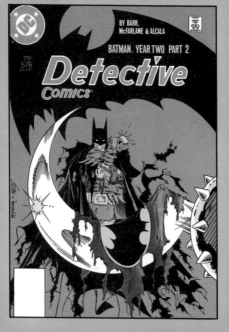

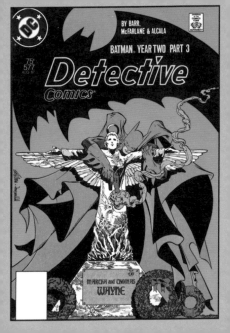

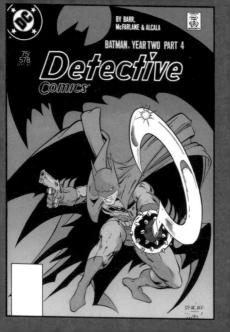

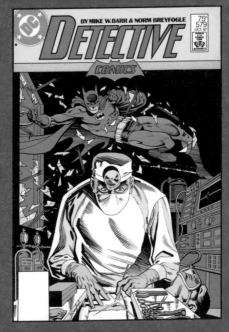

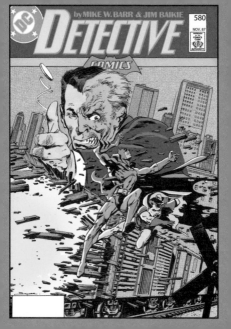

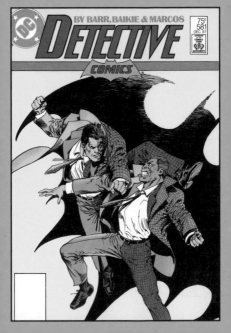

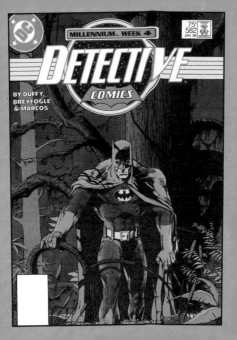

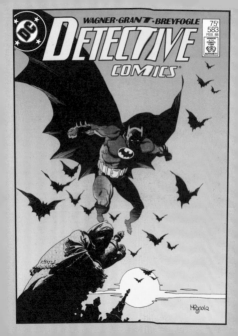

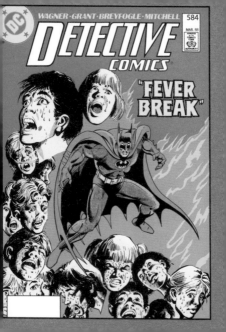

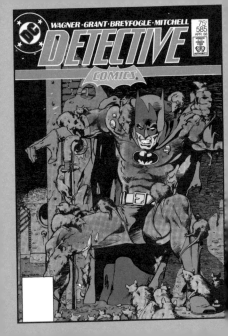

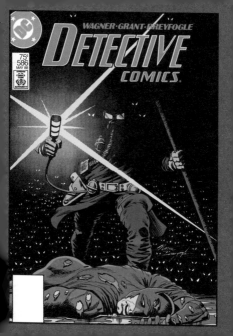

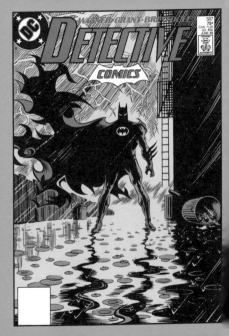

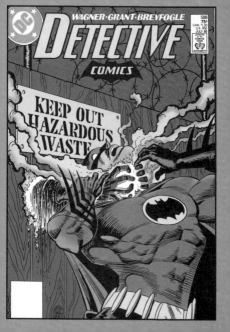

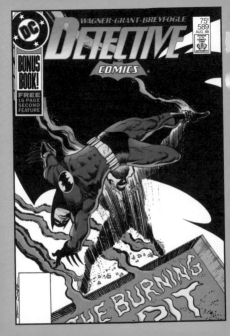

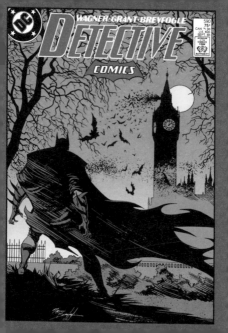

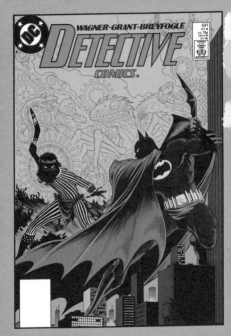

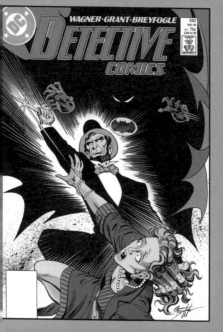

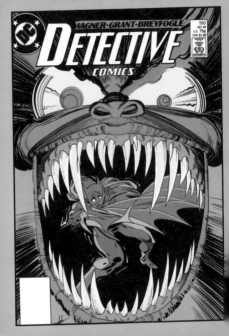

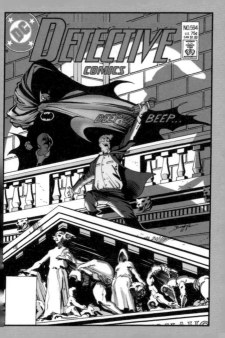

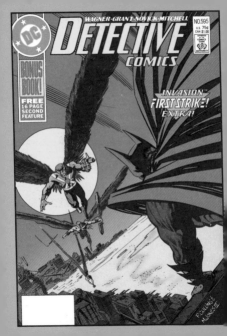

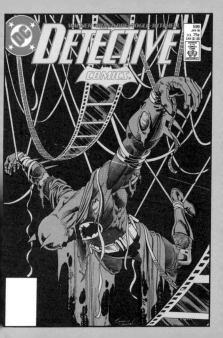

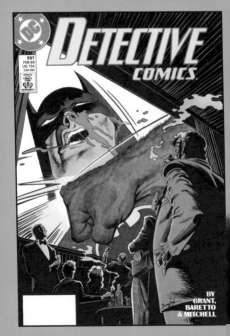

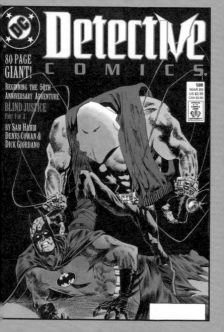

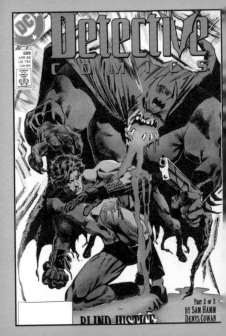

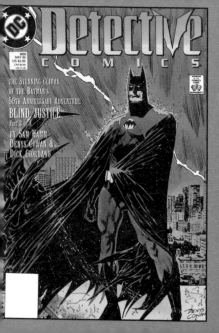

INSIGHT EDITIONS

PO Box 3088
San Rafael, CA 94912
www.insighteditions.com

 Find us on Facebook: www.facebook.com/InsightEditions

 Follow us on Twitter: @insighteditions

INED41435

Published by Insight Editions, San Rafael, California, in 2019.

Library of Congress Cataloging-in-Publication Data available.

ISBN: 978-1-68383-484-7

Manufactured in China by Insight Editions

10 9 8 7 6 5 4 3 2 1